Keepsakes
and Treasures

STORIES FROM HISTORIC NEW ENGLAND'S

JEWELRY COLLECTION

..

LAURA E. JOHNSON

Historic New England

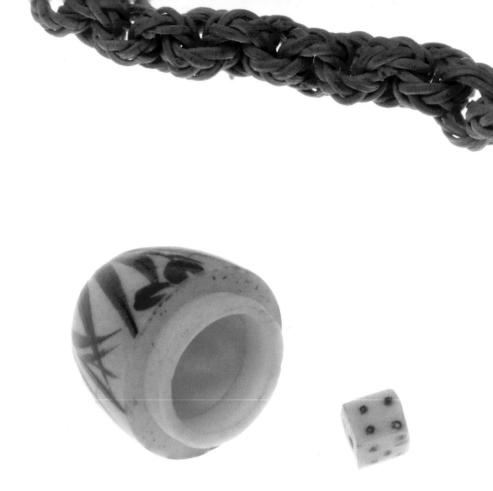

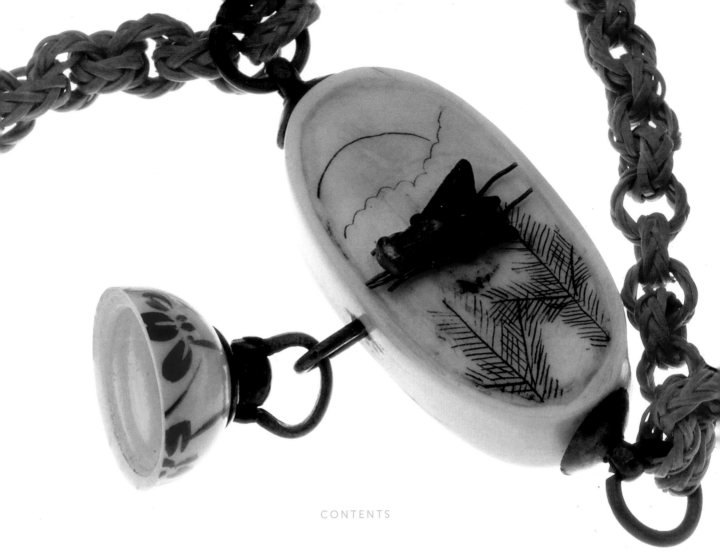

CONTENTS

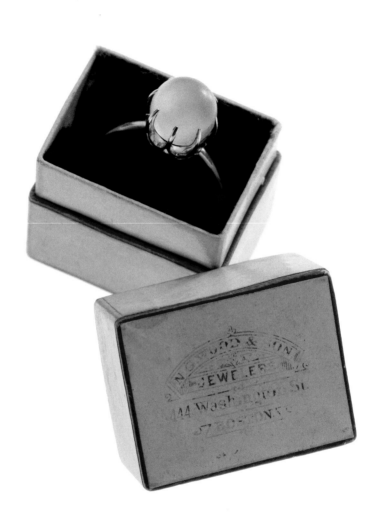

FOREWORD

. .

Archaeology shows that jewelry appeared tens of thousands of years ago,
and a trip to the mall or a walk down Main Street reveals how popular jewelry
remains today. Personal adornment may be symbolic of wealth, religious
belief, or cultural achievement, but it almost always is about personal
stories and memories. Jewelry is passed between generations, appears in
paintings and photographs, and is a source of storytelling among friends
and family. It is no surprise that the collections of Historic New England,
acquired from families throughout the region and dating from the seven-
teenth century to today, are rich in such objects. People want to preserve the
deep meaning associated with jewelry items, and museums like ours are
willing to record and share the stories on their behalf.

Keepsakes and Treasures: Stories from Historic New England's Jewelry Collection
can be enjoyed for many reasons. There is great design. There are examples
of items made in New England. There are poignant pieces representing love
and death. There is glitter and bling! Jewelry offers something for everyone.
We invite you to delve into the collection, and hope it will spark interest in your
own jewel box, which is a true repository of ideas, messages, and meaning.
This is history at its personal best.

CARL R. NOLD
President and CEO
May 2016

INTRODUCTION

.

In fine Gothic script, the gold clasp reads "AW to MW." Mary Goddard Wigglesworth married Boston lawyer Henry Pickering in October 1864. Her sister Anna chose the perfect gift to celebrate the union: a fine bracelet made from her own hair and inscribed with the sisters' initials. On the interior of the clasp Anna had the jeweler engrave the date of Mary and Henry's engagement, June 1864, and the address of the Park Street Church in Boston. Anna either wove the hair sections herself, passing strands of her hair over and under one another to create lace-like pipes, or she had a professional hair worker weave them for her. (1)

Hair bracelets often elicit shudders of distaste from modern audiences but "The Lock of Hair," a poem that appeared in an 1860s women's magazine, captures the essence of contemporary thought. The narrator, holding a lock of hair, exclaims, "How full thou art of memories, severed tress!" Today we might dismiss such cries as melodramatic but it was precisely the depth of feeling hair jewels engendered that made them popular. Hair has an almost talismanic power to connect the wearer and the owner.

Adornment is a personal narrative. Opening a jewelry box is like opening the cover of one's life story. Objects, writes Susan Stabile, "provide an immediate and seemingly unmediated link to the past." This book is a collection of those links, highlighting jewelry that preserves individual memories and works them into the broad chain of New England history. On these pages are keepsakes and treasures that tell stories of families, artists, and industries.

This collection is what jewelry has looked like for New Englanders since the mid-1700s. These stories are why it matters.

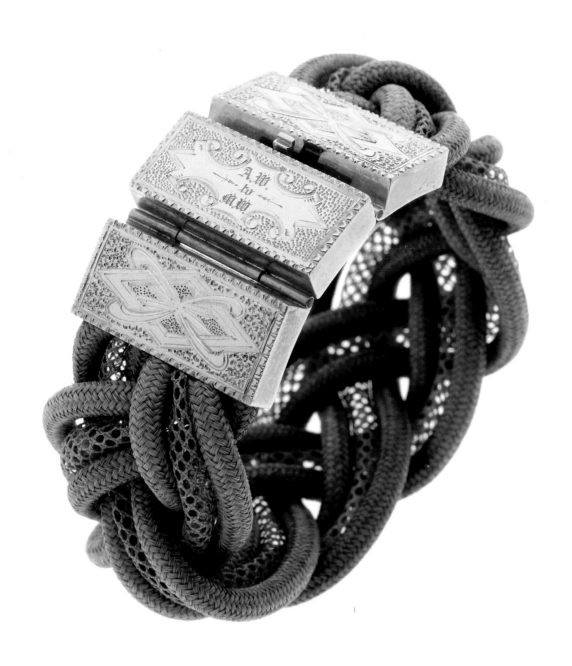

1

· · · · · · · · · · · · · · · · · · · ·

When lawyer Stephen Henry Phillips went to Boston jewelers Shreve, Crump & Low to buy a gift for his bride-to-be, Margaret Duncan, he did not choose a small piece of jewelry. Inside the blue satin box stamped with her initials and their wedding date, October 3, 1871, nestled an enormous necklace of gold links. A gold cross pendant and earrings, lavishly embellished with perfectly matched natural pearls, completed the set. After their wedding, Margaret wore the cross pinned to her collar, detached from its ornate chain, as in this 1887 portrait.

Legend tells that pearls, denoting beauty and purity, were first worn by the Greek goddess Aphrodite. Whether gathered from freshwater mussels or saltwater oysters, natural pearls are both rare and expensive. Few could afford necklaces such as Margaret Duncan Phillips's pearl-set cross. (2, 3)

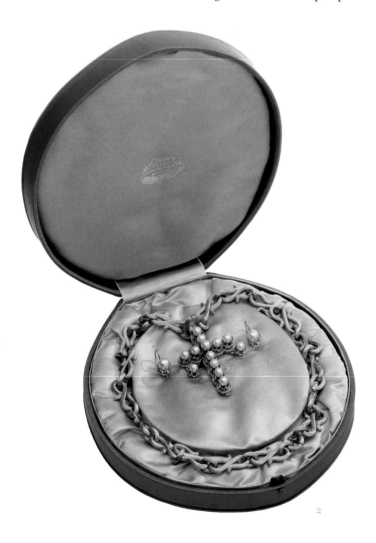

2

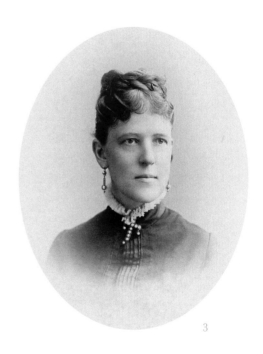

3

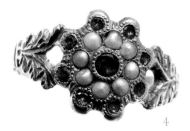

4

Small freshwater pearls could also be split in half and set like other gem-stones. Classical scholar and librarian Benjamin Hurd Rhoades declared his love for Harriet Philbrook Stillwell in 1833 with this ring, just after he graduated from Brown University, but it was another four years before they were married. The ring, with pierced shoulders and a rosette of pearls and garnets, is a typical 1830s design. (4)

...

As early as the sixteenth century inventors devised ways to mimic the lustre of natural pearls, with varying degrees of success. A popular recipe included filling blown glass with wax and ground fish scales. The wax filling and pearlized coating are visible in this closeup image of a faux pearl necklace. (5)

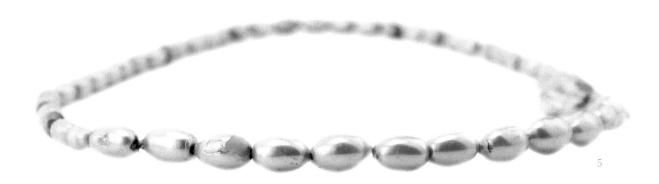

5

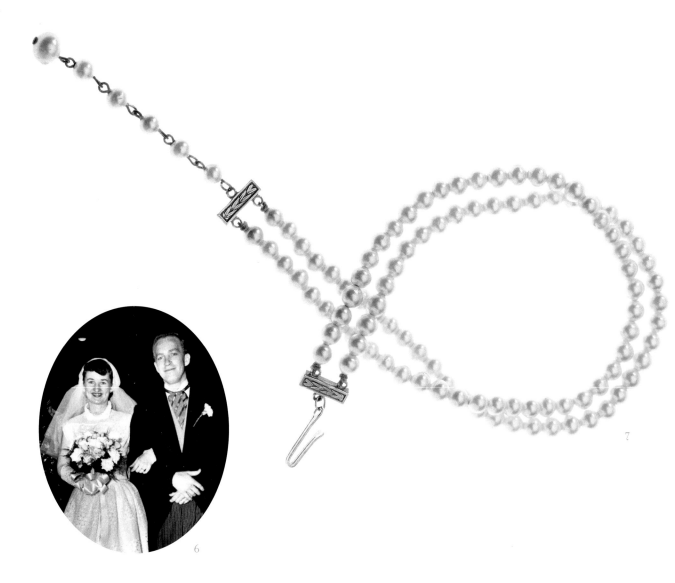

By the twentieth century dozens of companies were experimenting with imitation pearl recipes, from glass to early plastics. Theodora Kuhne wore two strands of faux pearls when she walked down the aisle with Albert Lawton in 1951. (6,7)

Jewelers frequently strung freshwater pearls as beads and then lashed them to carved mother-of-pearl frames with white horsehair, as in the earrings on the opposite page. (8)

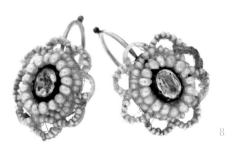

8

Harvesting the lining of a mollusc yields a nacreous layer called mother-of-pearl. Deborah Lang married William Putnam Richardson on August 6, 1807, in Salem, Massachusetts, wearing this mother-of-pearl comb brought from China by her intended or his father, both shipmasters in the East India trade. This elegant comb is engraved on both sides and bears Deborah's initials. (9)

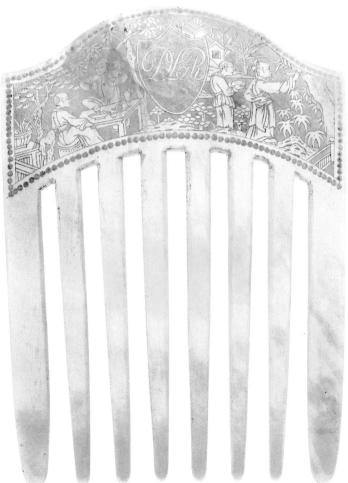

9

These exquisitely carved chalcedony cameos set in gold came from jeweler Diego D'Estrada's shop in Rome. Robert Means Mason and his wife, Sarah, purchased the set along with a set of vest buttons, possibly during a European trip in 1865. Sarah was an acute asthmatic and the family often traveled abroad for her health. Over the years the Masons brought enameled earrings, mosaic rings, coral necklaces, and other souvenirs home to Boston. Unfortunately, Robert returned home alone in 1865. Sarah died that fall in Dieppe, France. (10, 69)

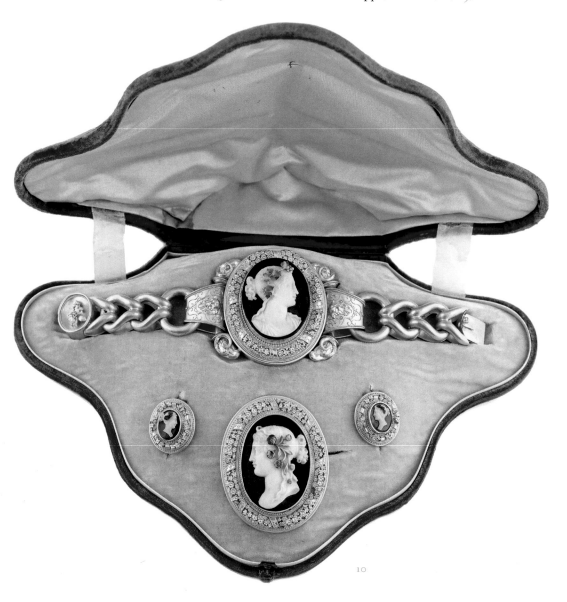

10

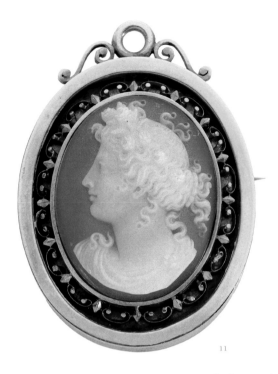

11

Harriet Fairbrother received this chalcedony cameo by Boston jewelers
Shreve, Crump & Low in 1871 for her wedding. She wore it with a set of fine
gold beads and orange blossoms in her hair. (11, 46)

12

Founded in 1796 by silversmith John McFarlane, Boston's oldest jewelry
store is best known by the names of three partners who joined the firm in the
nineteenth century. Shreve, Crump & Low continues to supply Bostonians
with fine jewelry, antiques, and silver. (12)

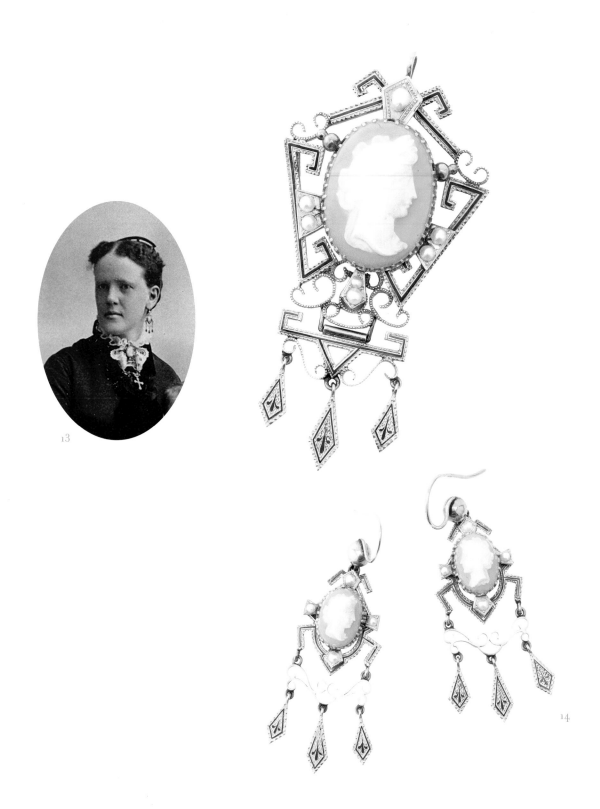

13

14

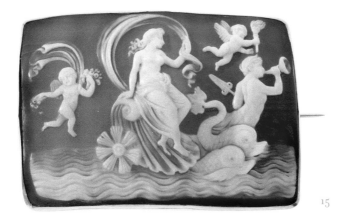

15

Margaret Duncan Phillips wore the large glass cameo with matching earrings pictured opposite when she posed for her portrait in 1876. (13, 14)

. .

Since antiquity men and women have valued gemstones engraved with portraits and mythical subjects. Bands of light and dark colors found in agates provided contrast for silhouetted images. Shell, ceramic, and glass cameos offered affordable options to chalcedony in a wider color palette.

Carved by Roman cameo artist and sculptor Constantin Roësler Franz, c. 1850, this shell cameo brooch depicts Venus in her chariot. Pinning the goddess of beauty to one's collar would have sent a subtle message about the wearer's powers of attraction. (15)

Introduced to Europe from India and Brazil, diamonds have always been expensive. To increase their sparkle jewelers often mounted stones—both real diamonds and false ones of glass or quartz—in white metal, which acted like a mirror and reflected light. By the end of the nineteenth century, discoveries of new diamond mines in South Africa, new metals such as platinum, and advanced cutting techniques led to a wide array of brilliant jewels, such as this white gold and diamond brooch. (16)

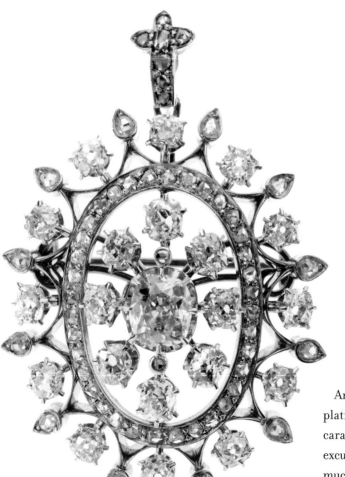

16

17

Anna Pingree Peabody most likely brought this platinum and gold brooch, set with fourteen carats of diamonds, home from a European excursion in the 1890s. She left it, along with much of her fine jewelry, to her niece Anna Wheatland Phillips upon her death in 1911. (17)

In ancient gem lore, rubies were believed to bring love to all in their presence. Stephen Willard Phillips chose wisely when he offered Anna Wheatland a ruby surrounded with diamonds. His diary noted a less auspicious beginning to their life together, when Anna tearfully confided that she could not marry him because she was in love with another. But a mere month later, in September 1898, they quietly announced to her mother that they were engaged. Anna proudly wears her ruby ring and her wedding band in this image taken in the summer of 1900. (18, 19)

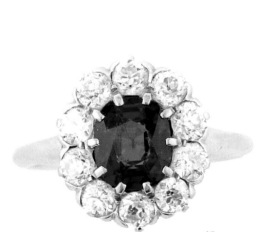

18

19

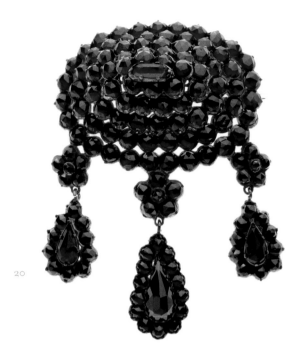

20

Tiny wine-red garnets from Bohemia, present-day Czech Republic, flooded
the jewelry market in the second half of the nineteenth century. Ancient Romans
believed that wearing garnets, named for their similarity to pomegranate seeds,
brought protection and luck. (20)

......................................

In the early twentieth century Vipont de Riviere Merwin owned this necklace
fashioned from an elaborate Victorian gold chain with two pairs of Art Nouveau
earrings and a large brooch. The stones are peridot, also known as chrysolite.
Gem lore associates peridot with the sun. It was believed that peridot, when set
in gold, could dispel enchantments and protect one from nightmares. (21)

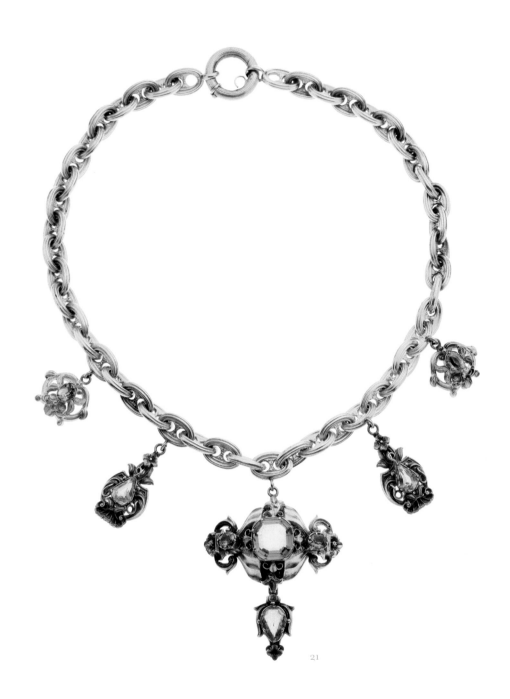

21

MEMORIAL

· ·

"Memorial jewels are exhibited secrets," writes historian Christiane Holm. From sepia-colored pendants to memorial rings mounted with tiny paper skeletons, the iconography of love and loss was meant for everyone to see.

· ·

For his daughter Hannah's wedding in 1797, Boston merchant Joseph Barrell commissioned a set of special adornments to celebrate family both living and dead. Hannah's mother, for whom she was named, was Joseph's second wife. She died when her daughter was three years old.

Barrell must have instructed London jeweler Stephen Twycross to take a ring commissioned when Hannah's mother died and alter it to become a brooch. The elder Hannah's 1777 death date and her initials are inscribed on the back. In its central scene Joseph Barrell battles Death, who approaches carrying a scythe, while holding his wife, Hannah. (22)

23

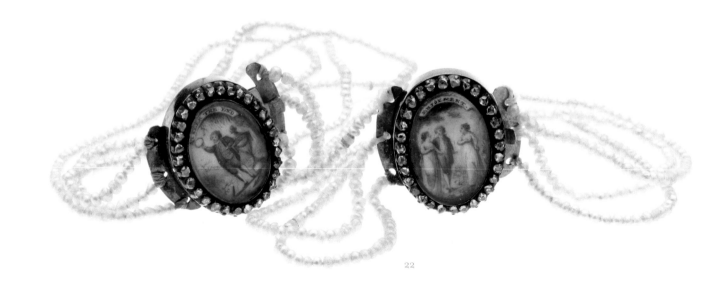

22

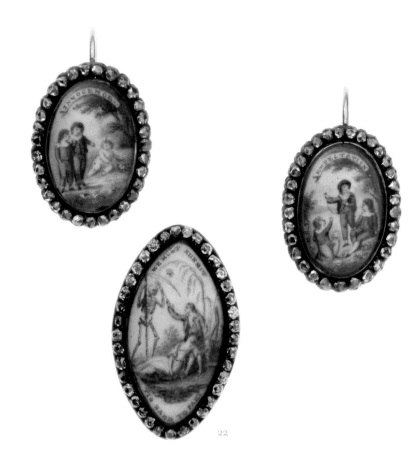

The earrings, inscribed "Innocence" and "Expectation," depict the younger Hannah's siblings. One bracelet depicts Joseph standing next to a funeral urn with the inscription, "I seek the end," while on the other, under the word "Enjoyment," he stands with his third wife, Sarah Webb Barrell, and his daughter. Joseph Barrell relied on hope and faith in equal measure, as his family's jewelry indicated. While the imagery might be an unusual choice for bridal jewelry today, death was an integral part of life in early New England. (22)

. .

The brooch at left is typical of many late eighteenth-century mourning jewels. Painted on ivory with human hair mixed into the pigment, it depicts a woman mourning a loved one who is welcomed into heaven by a winged cherub. The inscription, "Not lost but gone before," would have reminded mourner and viewer alike that all will be reunited after death. (23)

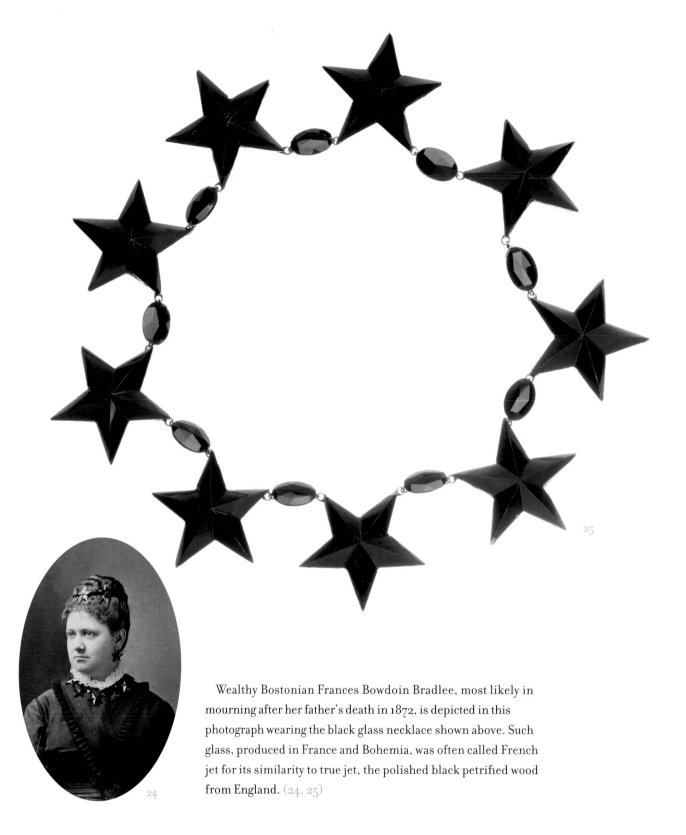

Wealthy Bostonian Frances Bowdoin Bradlee, most likely in mourning after her father's death in 1872, is depicted in this photograph wearing the black glass necklace shown above. Such glass, produced in France and Bohemia, was often called French jet for its similarity to true jet, the polished black petrified wood from England. (24, 25)

The death of George Washington in 1799 sent the young Republic into deep mourning. The outpouring of grief translated into a wide range of commemorative objects and elaborate funeral processions across the country. A silversmith in Newburyport, Massachusetts, designed this medal specifically for children to wear at Washington's memorial processions. (26)

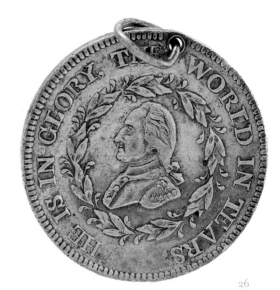

26

. .

This unusual double mourning ring commemorates husband and wife Zephaniah and Hannah Leonard, who died on the same day in 1766. Beneath the coffin-shaped crystals lie tiny drawings of skeletons. Mourning rings from this period often included such reminders of death's presence, recalled in the common phrase memento mori or "remember death." Family tradition held that the eldest daughter of the eldest son in each generation would inherit the ring. (27)

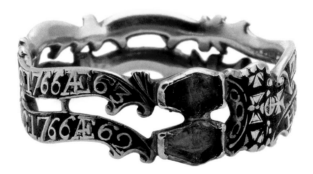

27

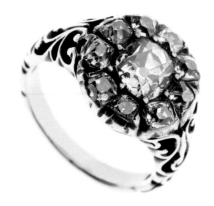

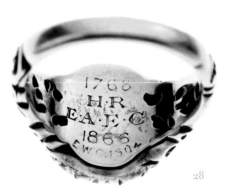

28

Thomas Robison gave this diamond ring to Elizabeth Cartwright when they married. Their daughter Hannah, her daughter Elizabeth, and then her nephew Edward, each inherited and inscribed birth or death dates on this family jewel. Like the Barrell family's jewelry, this ring celebrates loved ones past and present. (28, 22)

..

Emily Marshall Otis was the granddaughter of Boston mayor and United States senator Harrison Gray Otis. He died in October 1848 just days after Emily's brother George Harrison succumbed to polio at age thirteen. Emily commemorated both losses with this brooch containing locks of their hair. (29)

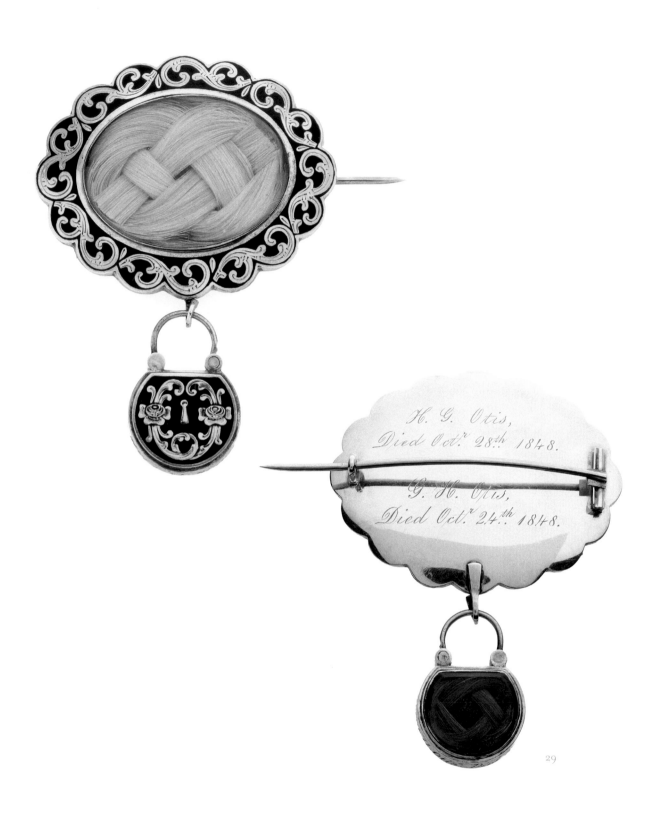

29

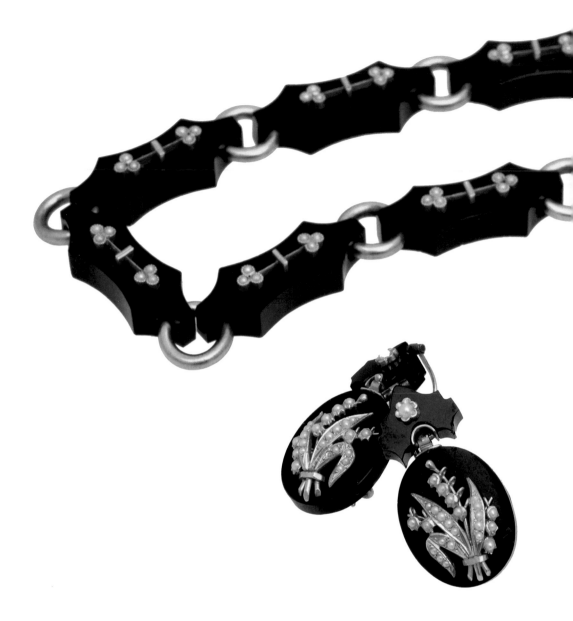

Nineteenth-century concepts of mourning and loss included sentimental thoughts about a loved one's soul and the beauty of his or her passing. Mourning was equal parts celebration and remembrance. Often a locket held an image as well as a lock of hair. Lilies of the valley, frequently chosen as a memorial flower, symbolized a return of happiness.

In 1887 Sarah Elizabeth Silsbee Woodbury, in mourning for her father, Nathan Silsbee, wore a chain of gold and jet links embellished with gold and pearl lilies of the valley. The pendant contained a photograph, possibly of her father. (30)

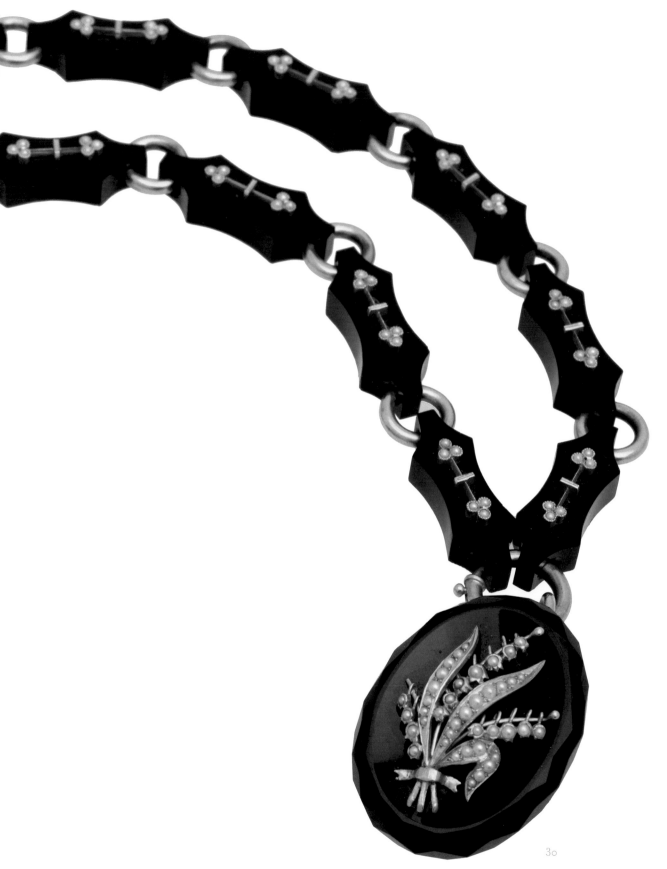

30

MEMORIAL

Stephen Borkowski and his partner Wilfrid J. Michaud Jr. fell in love with these romantic gold bands when they saw them in the front window of Tiffany & Co. in Palm Beach, Florida. Once they returned to Boston they made a trip to Tiffany's at Copley Place, where they had the jeweler customize each band with their initials and the dates of their decade of life together.

Upon Wilfrid's death in 2002 Stephen added another engraving, "UBLUD," which stands for united by love until death, inspired by the classic 1968 film *Mayerling*. The couple was never able to officially marry as Massachusetts did not pass a marriage equality law until May 2004. (31)

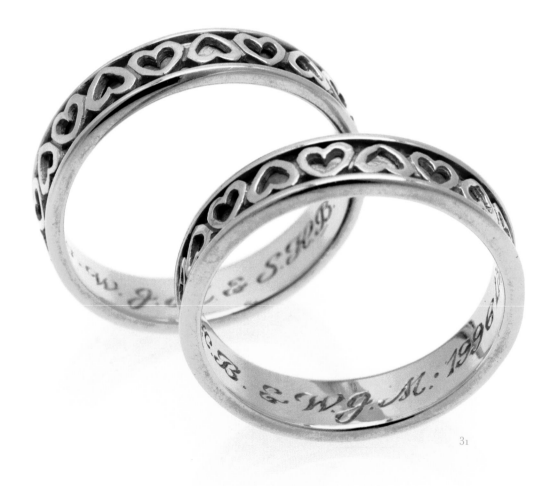

31

Anna Wheatland Phillips purchased this pair of bracelets from Tiffany & Co. in the 1890s as a token of affection for her aunt, Anna Peabody. She had each of the gold bands inscribed with their names. The bracelets, still in their original silk-lined case, were one of many gifts that passed between Anna and her favorite aunt. (32)

32

Posy rings are named for the rhyming verses or mottoes with which the rings are engraved. Some, like this one from c. 1750, might remind the owner to "Let virtue be a guide to thee." (33)

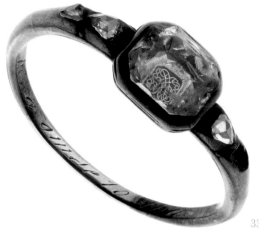

Hoop rings symbolize one's unending love. Charles Whiting had this ring engraved in 1822 for his wife Harriet Homer with "CW to HH, Remember the giver." (34)

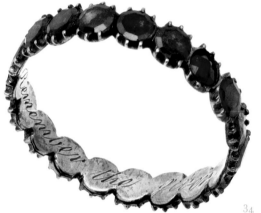

The hands on this c. 1800 ring open and close over a golden heart. Colonial Americans called them heart-in-hand rings for that reason, after the ancient Roman versions known as *mani en fede*. (35)

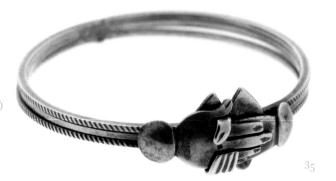

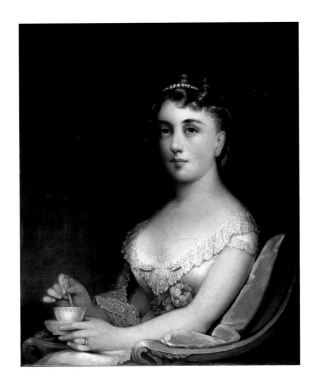

36

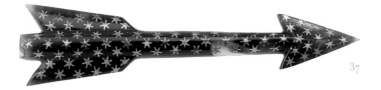

37

The arrow, Cupid's favorite weapon, was another popular symbol of affection. Jane Stuart, the daughter of famed portrait artist Gilbert Stuart, painted Mary Edwards Honey dressed in the latest fashion for evening entertaining in the late 1860s. She wears a large Cupid's arrow brooch pinned in her lace collar. The tortoiseshell brooch seen above is from the same era. It is set with tiny gold stars, a French technique called piqué. (36, 37)

Love gifts extended far beyond rings. Especially in the 1830s young women spent hours carefully weaving pocket-watch chains for their loved ones. Tiny glass beads spelled out messages and depicted love symbols such as pairs of gold rings, hearts, anchors (a symbol of hope), and keys (to one's heart). (38)

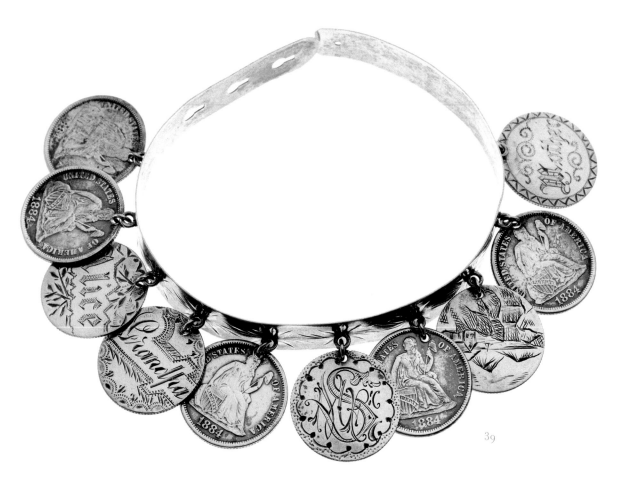

This silver bracelet belonged to Lydia Chace of Providence, Rhode Island, possibly a gift from her mother, Ella. It documents three generations of the family—cousins and aunts, grandfathers and sisters. Silver coins were an affordable material. Jewelers could file down the faces to create a perfect surface on which to engrave names of loved ones. This is far more than a love token, even though collectors often give these coin jewels that name. This bracelet was a family heirloom, a wearable family tree. (39)

· · · · · · · · · · · · · · · · · · · ·

Adorning oneself in the latest styles did not always demand expensive gems or precious metals. Even the wealthy wore imitations. Faceted leaded glass, called paste, could polish up to look like diamonds or, with the right bit of colored foil behind the stone, topaz. Pinchbeck, a mixture of copper and zinc named for its inventor, Christopher Pinchbeck, looked just like gold.

The pieces shown here all date to the eighteenth century. The cufflinks are pink-foiled paste with gold wire patterns designed to resemble a monogram. The rosette earrings of paste and pinchbeck would have flashed like diamonds in candlelight. Pastes could even be set in precious metals. The heart-shaped bosom pin, which might have closed a woman's neckerchief, is made from silver and gold but is set with clear and pink-foiled pastes. (40–42)

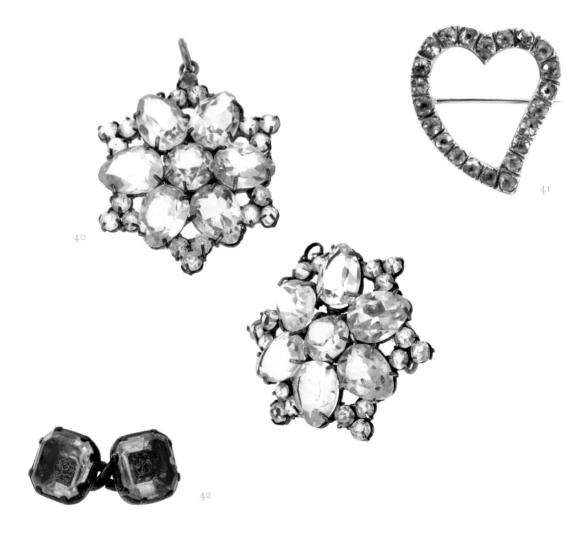

40

41

42

This chatelaine combines pinchbeck with painted ivory miniatures and marcasite decorations, the latest jewelry trend for the 1790s. Chatelaines, worn with the large tab at the back tucked into a waistband, allowed women to keep keys, scissors, needles, and other equipment close to hand. (43)

When Benjamin Joy married Hannah Barrell in 1797 his shoe buckles far outshone his bride's delicate ivory miniatures. These enormous buckles are made of silver, gold, and topaz-foiled pastes, suitably glamorous accessories for America's first consul in Calcutta, India. (44, 22)

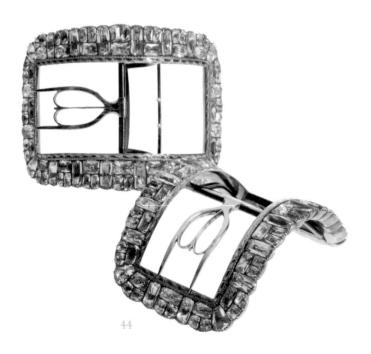

44

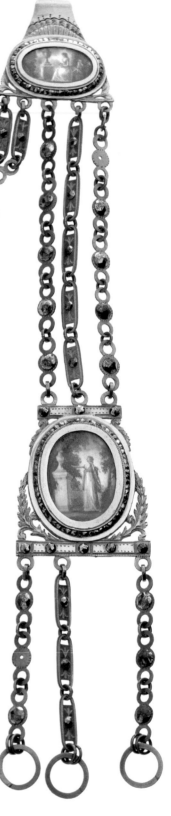

43

Enameled iron household goods made in Berlin were available in the United States by the 1840s, but jewelry made from this material was an exciting innovation. The Codman family of Lincoln, Massachusetts, might have acquired this delicate, enameled iron cross suspended from chain mail during one of their many trips to Europe. (45)

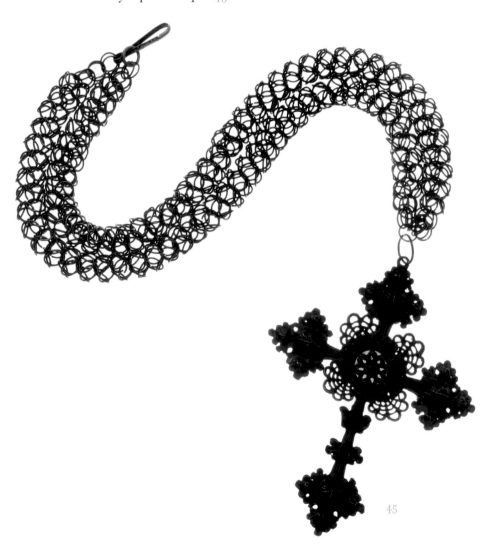

45

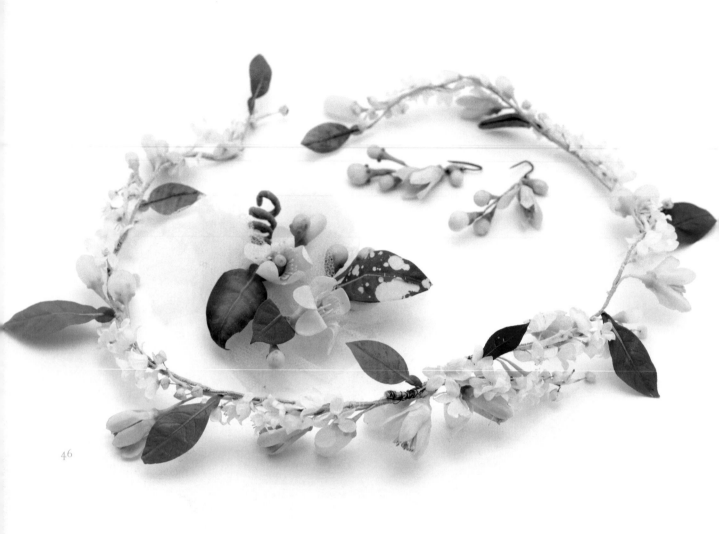

46

Professional milliners and schoolgirls alike produced artificial flowers from silk and wax, such as this head ornament, earrings, and corsage worn by Harriet Fairbrother at her 1871 wedding. For decades after Queen Victoria's wedding in 1840, many brides copied her dress, hairstyle, and orange blossom wreath. In the language of flowers orange blossoms denote purity. (46)

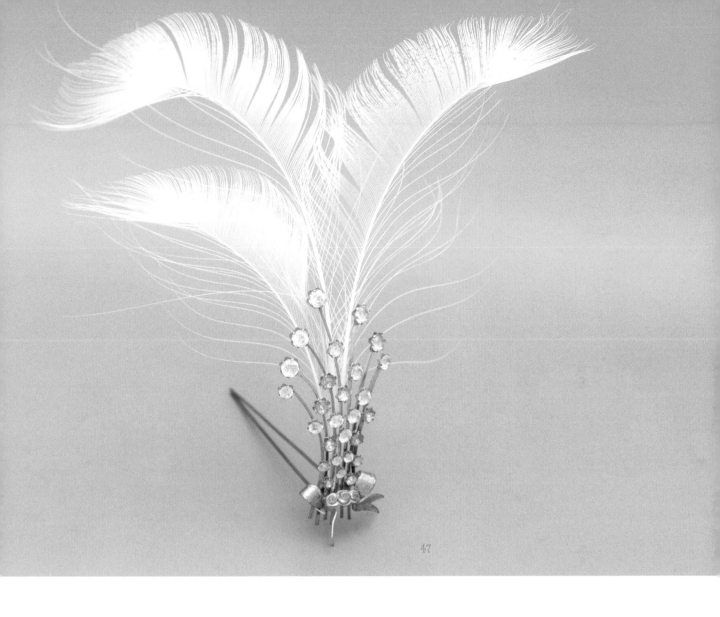

47

Whether made of cut quartz crystal or glass, imitation diamonds shimmered on accessories such as tiaras and aigrettes. Aigrettes, a type of hair ornament embellished with feathers, were popular in the 1880s and '90s. (47)

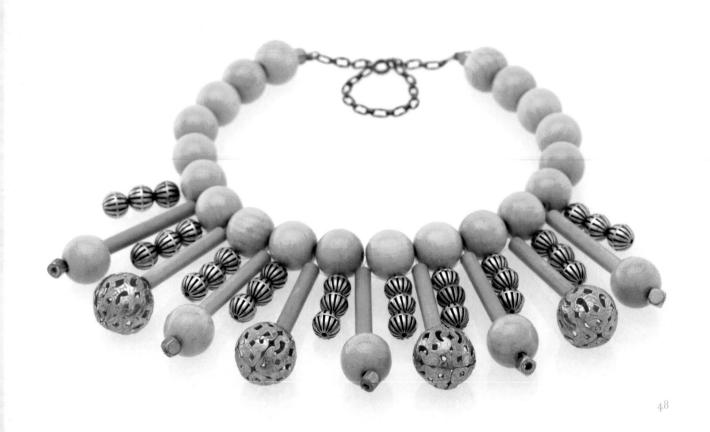

48

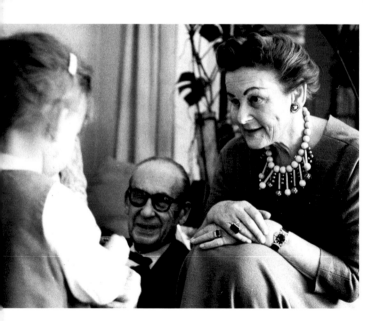

49

50

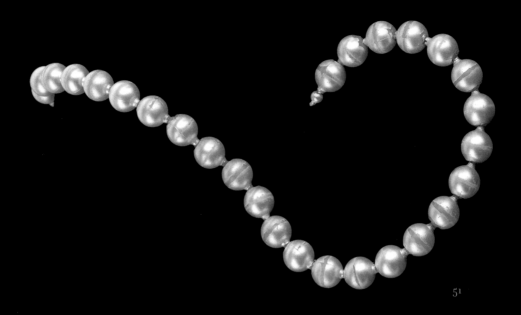

51

Finding beauty in the mundane was particularly important to artists trained at and influenced by the Bauhaus in Germany. Anodized aluminum, plain wood, and even electrical fixtures could be turned into jewelry. The necklaces shown at left belonged to Ise Gropius and Ati Gropius Johansen, the wife and daughter of Bauhaus founder Walter Gropius. Many of Ise Gropius's jewels were gifts from friends and family. Others, like the fringe necklace visible opposite that she wears in this c. 1960 photograph, she most likely purchased at her favorite Cambridge, Massachusetts, store, Design Research. Ati's husband, architect John Johansen, made the choker necklace out of metal elbow joints. (48–50)

. .

In the 1950s costume jewelry companies, including Coro of Providence, Rhode Island, and Richelieu of New York, debuted plastic beads that strung together with a ball-and-socket connection. These so-called pop beads could adjust to form an opera-length rope or a choker in seconds.

Noted folk art scholar and collector Nina Fletcher Little wore these faux pearl pop beads nearly every day in the last years of her life. (51)

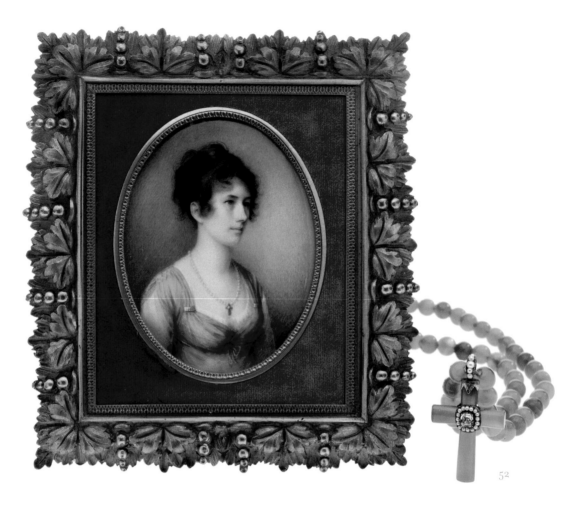

52

For her 1804 portrait Sally Foster Otis, wife of Boston mayor and U.S. senator Harrison Gray Otis, wore a carnelian cross on a string of pearls. Renowned for her beauty and sparkling conversation, Mrs. Otis was the toast of Washington society. At the turn of the nineteenth century, when Mrs. Otis wore this set, Boston jewelers sold pendants like this one with interchangeable strands of matching beads or pearls. Nearly a century after Sally owned it, an Otis descendant had the necklace re-strung with a set of matching carnelian beads. (52)

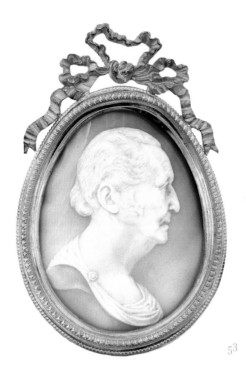

53

This large shell cameo portrait of Harrison Gray Otis, carved in 1849 by Boston sculptor John A. Greenough, depicts the Boston politician as a classical figure. Greenough, whose brothers Horatio and Richard were also sculptors, studied portraiture and cameo carving in Rome before returning to Boston. (53)

Years before photography, painted miniature portraits offered a way to keep one's dearest love close by. Elisha Doane had this portrait miniature completed prior to his marriage to Jane Cutler in 1783. His family later combined it with one of the coat buttons he wears in the portrait, doubling the object's power as a keepsake. (54)

54

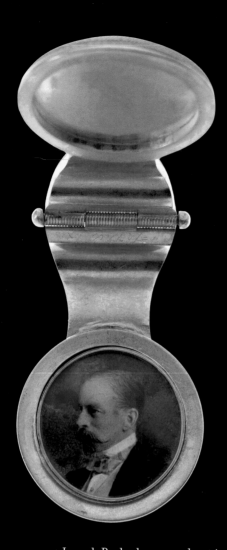

55

Joseph Peabody, a merchant in Salem and Boston, Massachusetts, had his portrait set in an Italian micromosaic pendant called a *bulla* for his wife, Anna Pingree. Ancient Romans believed that a bulla offered protection to those who wore it. Jewelry based on archaeological designs was enormously popular in the second half of the nineteenth century. (55)

.......................................

Lawrence Rhoades was a Providence, Rhode Island, bookkeeper by trade who rose to become a brevet colonel in the Civil War. After the war he made his wife several love tokens. Among them was this extraordinary brooch, carved from tortoiseshell and set with his photograph. (56)

56

Daguerreotypes were the first commercially successful form of photography. This extraordinary portrait bracelet contains the images of presidents John Adams and John Quincy Adams along with four world-famous scientists, with a lock of each man's hair on the reverse. The bracelet belonged to Mary Quincy Gould Thorndike. It was most likely given to her by her mother, Mary Quincy Gould, or her sister Alice Bache Gould.

Why were these six men so meaningful to Mary? Through her mother, she was a descendant of an extended branch of the Adams family. Her father, Benjamin Gould, a mathematician and astronomer, helped found the National Academy of Sciences in 1863 with three of the men pictured. Alice, who studied mathematics like her father, might have commissioned the bracelet to commemorate both sides of the family tree. The combination of photography and hair created a doubly potent memento for this family. (57)

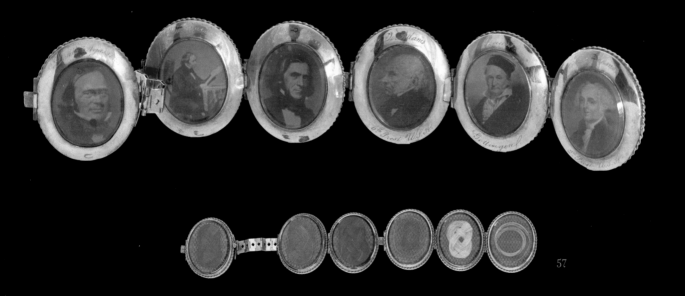

57

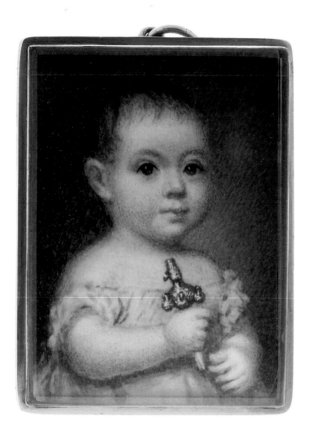

58 59

Many parents believed that coral had protective powers. Its smooth
texture also made it a popular choice for teething handles on rattles.

Elizabeth Gilbert's parents commissioned a portrait of her holding
her silver and coral rattle in 1839 when she was only ten months old.
Elizabeth's niece inherited both portrait and rattle. (58, 59)

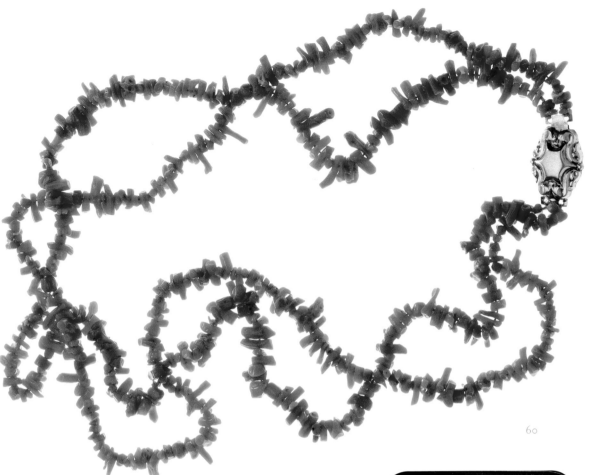

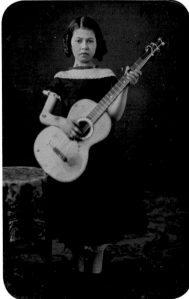

Mehitabel Bangs from Brewster, Massachusetts, received this coral necklace inscribed with her name, most likely as a gift from her parents in the 1840s. (60)

...

Susan Austin wore a similar coral necklace when she posed for this c.1855 daguerreotype, which was hand-colored. (61)

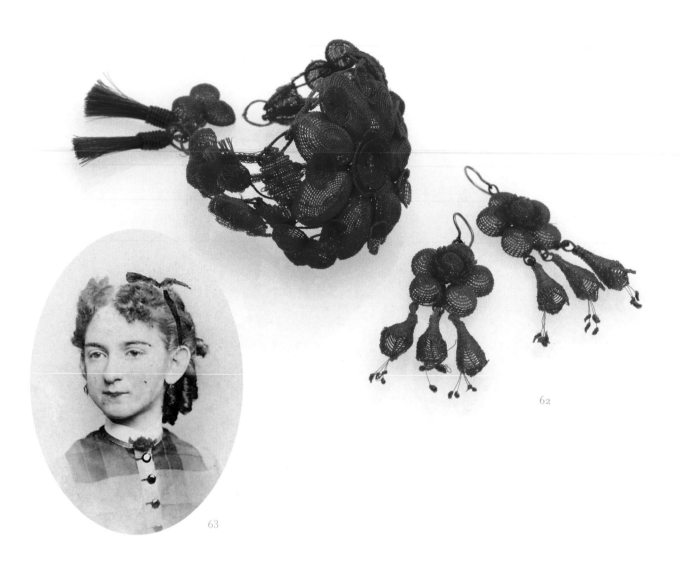

62

63

Beginning in the early nineteenth century young children wore "dandies," which were necklaces, bracelets, even earrings woven from dyed horsehair. This set came down through a Massachusetts family. A member of the Phillips family of Salem, Massachusetts, either Jane Appleton Phillips or Jessie M. Kimball, wore a nearly identical pair of earrings with a matching brooch in her 1866 portrait. (62, 63)

...

One of the most common forms of adornment for men, signet rings were also popular gifts for children throughout the nineteenth and twentieth centuries. Ralph C. Bloom received this miniature gold signet ring as a christening present in 1942. (64)

64

SOUVENIRS

· ·

By the early nineteenth century New Englanders traveled for pleasure, education, and business. Many believed that extended journeys through Europe, sometimes called the Grand Tour, increased one's taste and refinement. Travelers brought home souvenirs including artwork, photographs, local crafts, and antiques. Author Susan Stewart describes souvenirs as "traces of authentic experience." Jeweled keepsakes were both portable and visible, allowing the owners to recall those traces for eager audiences and evoke their favorite travel moments.

· ·

From carved oak recovered from Irish bogs to ivory bracelets from Germany to Scottish agates, New Englanders purchased jewelry to commemorate their overseas journeys. (65–67)

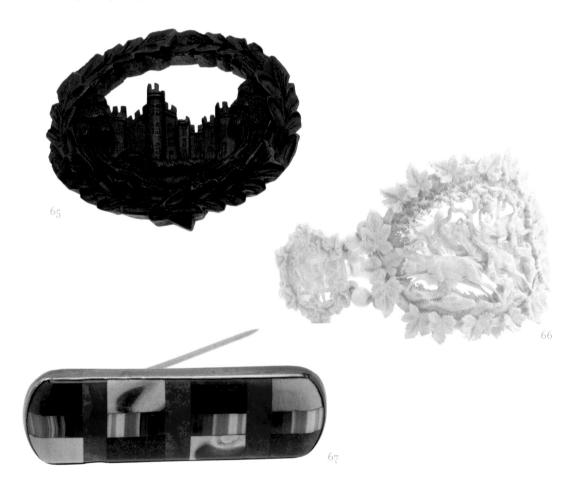

65

66

67

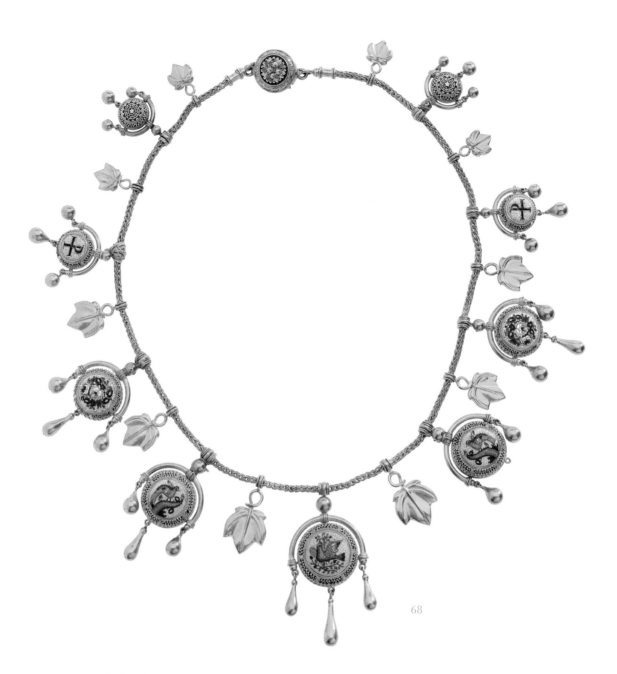

68

Before his marriage, Captain Richard Tucker embarked on a tour across
Europe to Russia in 1857. Tucker acquired many gems for his future wife,
Mollie, including this Roman micromosaic necklace. Sometime after
settling in Wiscasset, Maine, the family's fortunes suffered a downturn and
Mollie struggled to maintain her earlier lifestyle. She must have cherished this
necklace, as she continued to carefully reinforce the pendants with gold-colored
thread after the original gold connectors began to break. (68)

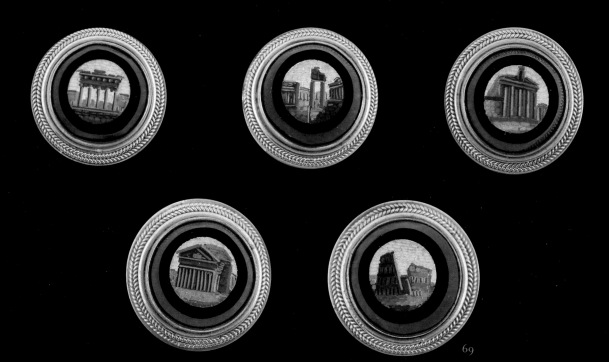

69

Italy was a key destination on the Grand Tour. Italian jewelers excelled at creating both affordable trinkets and monumental suites of jewelry for tourists. These souvenirs ranged from micromosaic images of the Coliseum and other Roman ruins, such as these vest buttons from a set purchased by Robert Mason, to the Papal Basilica of St. Peter in the Vatican, as depicted on this brooch. (69, 70)

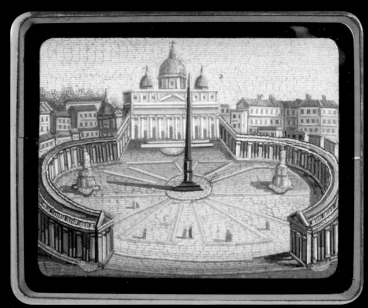

70

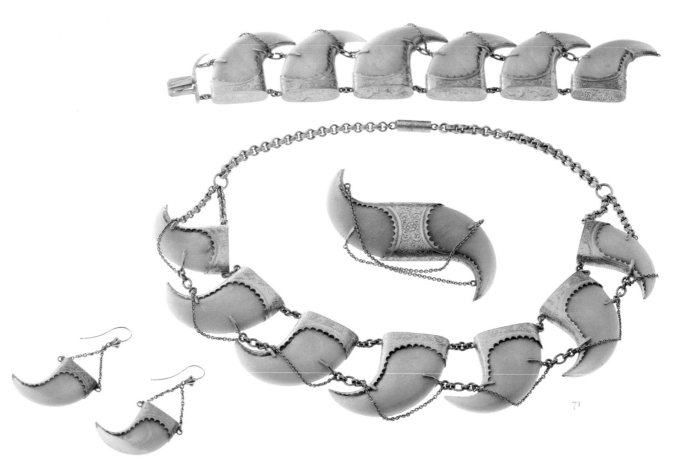

This set of tiger claw jewelry, called a parure, includes a necklace, bracelet, earrings, and brooch. It was purchased in Bombay (now called Mumbai), India, in 1875 as a gift for the popular Cambridge, Massachusetts, author Georgina Lowell Putnam. Indian-made sets of tiger claw jewelry were quite fashionable as hunting trophies and tourist souvenirs in the nineteenth century. (71)

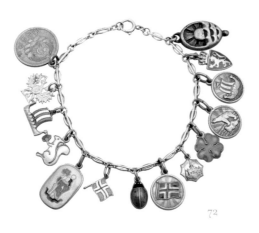

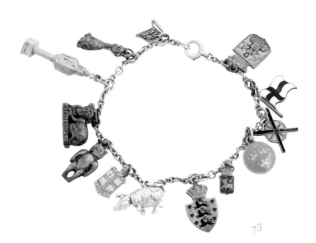

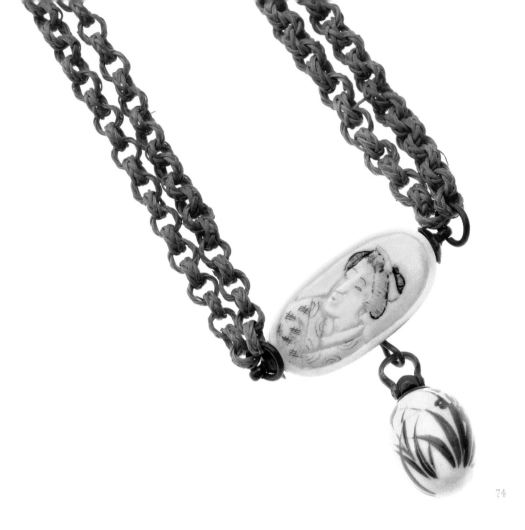

74

By the turn of the twentieth century tourists could display an entire trip on their wrists. Vipont de Riviere Merwin documented her journeys through the United Kingdom and Scandinavia in the 1930s with this pair of bracelets. (72, 73)

. .

New England sailors returning from East Asia presented their loved ones with gifts of ivory and jade. Family history holds that paymaster Samuel T. Browne came back from Japan to Rhode Island in 1867 with the above object made of straw, ivory, silver, and garnet. Browne most likely used it as a watch chain and fob but a later owner added a clasp and turned it into a necklace. (74)

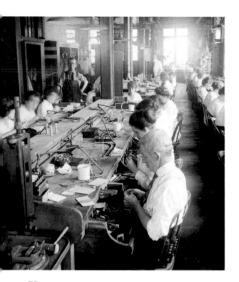

75

From a single artist at her bench to hundreds of employees in large factories, New England artisans have always formed the heart of American jewelry production. (75)

By the mid-nineteenth century manufacturing jewelers in Providence, Rhode Island, and Attleboro, Massachusetts, produced more than one quarter of the jewelry in the United States. Hundreds of companies created a wide range of jewels, from inexpensive stamped novelties to gold bracelets set with diamonds. Providence-based Louis Stern & Company created the bracelet below plated in green, yellow, and rose gold around the second quarter of the twentieth century. (76)

At the opposite end of the spectrum were artists like Boston jeweler Frank Gardner Hale and his student Edward Everett Oakes. Hale was part of a growing reaction against the mass production that had accelerated throughout the nineteenth century. Hale brought techniques he learned from English Arts and Crafts jewelers home to Boston. His leadership in The Society of Arts and Crafts, Boston, profoundly influenced American jewelers. The brooch opposite unites gold in a sinuous Art Noveau motif with a green tourmaline from Maine, a combination typical of Hale's style. The brooch remained in Hale's family until recently. (77)

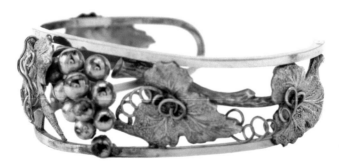

76

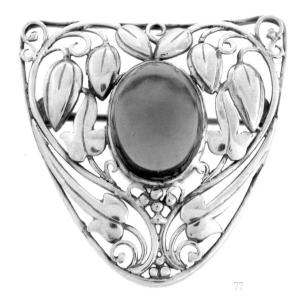

77

Hale's influence is clear in the brooch below by Edward Everett Oakes, a member of the second generation of Boston Arts and Crafts jewelers. Made for museum educator Barbara Wriston while she worked in Boston in the 1940s, it combines opals, diamonds, pearls, and pink tourmalines. (78)

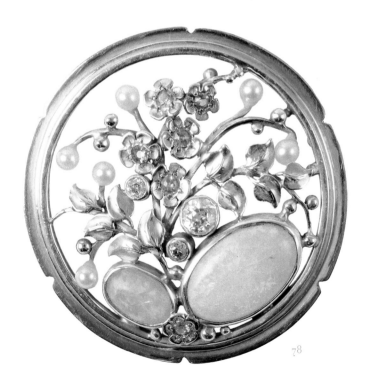

78

79

80

Oakes also designed these wedding and engagement rings for Marguerite Woodworth, who married Barbara's father, Henry Wriston, in 1947. The notched edges visible in the gold brooch are also seen along the edges of Marguerite's platinum, diamond, and sapphire wedding band. The companion engagement ring is an elegant gold daisy chain, most likely a play on the owner's name, as marguerite is a variety of daisy. (79)

It was not until the turn of the twentieth century that women could pursue significant opportunities in the traditionally male fields of jewelry design and production. Pioneers such as Josephine Hartwell Shaw, who studied with Hale and under whom Oakes apprenticed, and Grace Hazen were among the first to join The Society of Arts and Crafts, Boston.

When they opened their first gallery in 1927, Italian-born sisters Delfina Parenti and Zoe Parenti Borghi were among the second generation of Boston women who designed and sold their own jewelry. A 1941 *Vogue* article featured the "Misses Parenti," emphasizing their love of aquamarines, moonstones, and silver work in both antique and contemporary styles. This silver and quartz ring is typical of their modern designs. The Parenti sisters maintained their Boston gallery until 1973. (80)

This 1940s sterling silver bird brooch by Coro of Providence was a direct copy of a dove brooch designed for Danish master Georg Jensen. (81)

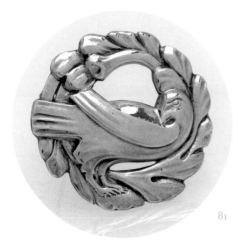

81

82

Companies began mass producing versions of mid-century Modern jewelry, such as this brooch by Providence-based Danecraft. While many companies moved overseas after the 1970s, hundreds of jewelry designers and makers continue to call Rhode Island home. (82)

..

After the First World War, under the direction of designers such as Coco Chanel, fashion trends moved toward accessories that made a statement. These costume pieces often copied, or at least hinted at, jewels made with real gems and precious metals. New England's manufacturing jewelers dominated production of costume jewelry. Although these jewelers produced on an enormous scale, each piece had the feel of a work of art, priced from a few pennies to more than fifty dollars, at least a month's wages for the average American in the 1940s.

The bracelet below, by Trifari of Providence and New York, was designed by Alfred Philippe to approximate similar pieces by luxury jewelers Cartier and Van Cleef & Arpels. (83)

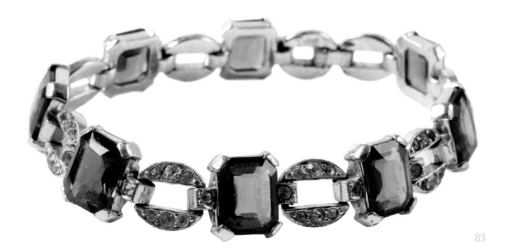

83

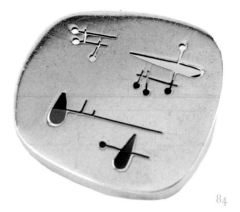

84

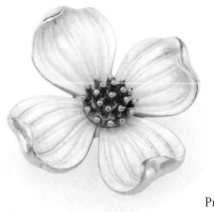

85

Beginning in the 1940s and '50s jewelers explored the frenzied pace of modern postwar life in syncopated designs such as the pierced silver brooch above. Ed Weiner and his wife, Doris, were like many artists who traveled to Provincetown at the tip of Cape Cod for respite from New York's summer heat. Weiner said that the "atmosphere of inquiry and persuasion, studio visiting, and talk, talk, talk" of Provincetown's summer scene was his art school. Along with Henry Steig, Paul Lobel, Jules Brenner, and others, Weiner helped invigorate Provincetown's mid-century jewelry scene. (84)

. .

White-enameled jewelry had a particular vogue in the mid-1950s but this dogwood blossom remained one of Trifari's most popular designs for decades. This brooch belonged to the donor's aunt, who always wore costume jewelry to complement her work clothes. (85)

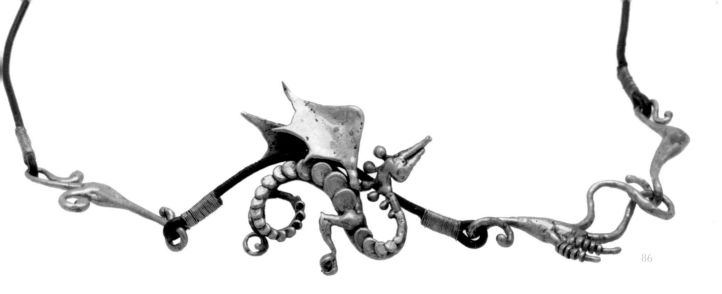

Provincetown artist Carl Tasha was also largely self-taught. Beginning in the 1960s, he embraced non-traditional styles, materials, and techniques. He melted brass with a hand-held torch, then created sculptures by dripping and hammering the metal. Large dollops formed individual scales and horns on this whimsical brass dragon pendant. Tasha often created molds from his original pieces, casting brass and precious metal copies in limited editions. (86)

..

For his *Creation* cuff, artist Jason Brown, a member of the Penobscot Nation, combined copper and ash splints to depict the Wabanaki people's origin tale about their cultural hero Gluskap. Striking a brown ash tree with his arrow, Gluskap split the tree open and the Wabanaki appeared. Cut in copper silhouette against a background of woven ash splints, Brown's cuff depicts the moment Gluskap's arrow struck the tree. (87)

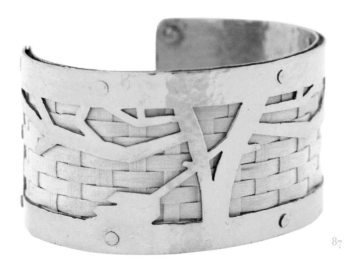

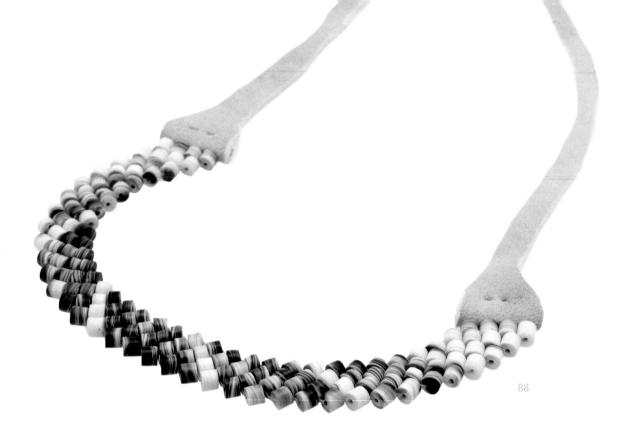

88

The work of contemporary New England jewelers often explores ancient techniques and traditions to connect with and comment on the world around them. A member of the Wampanoag Tribe of Gay Head (Aquinnah, Massachusetts), Elizabeth James-Perry used wampum—beads made from shells of quahog clams native to the southeastern New England coast—to create her *Alliance* collar. For James-Perry, jewelry "is the way we choose to honor each other, Mother Earth, and the rest of creation." (88)

Given as gifts to mark major life transitions, prized as keepsakes of triumph or tragedy, collected for their history and beauty, jewelry and adornment are visible stories. Looking at the pieces, handling them, and wearing them collapses the distance between then and now, evoking memories of a favorite moment, person, or place.

Historic New England's jewelry collection spans centuries of family tales, industrial development, and artistic expression unique to the region. Each piece, whether a family heirloom or a contemporary accessory, that we add to the collection illuminates a facet of our shared New England history.

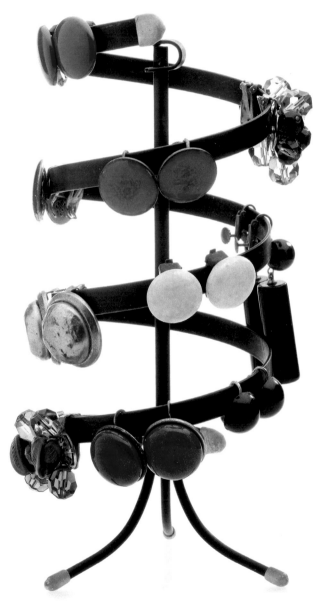

CHECKLIST

· ·

TABLE OF CONTENTS

Necklace. Japan, c. 1865. Straw, ivory, silver, garnet. 6"L. Gift of Miss Hannah May Burrough, 1925.244.

FOREWORD

Ring. N. G. Wood & Son (retailer), Boston, Massachusetts, 1870–1910. Moonstone, gold. ⅜"W, ¾" diam. Bequest of Edgar J. Rollins, 1946.680.

INTRODUCTION

1. Bracelet. Massachusetts, 1864. Gold, human hair. 1"W x ¼"D x 2 ⅞" diam. Estate of Mrs. Jane N. Grew, 1920.546.

PEARLS

2. Set of jewelry in original case. Shreve, Crump & Low (retailer), Boston, Massachusetts, c. 1871. Gold, pearls. Necklace: 11 ½"L; pendant: 2 ¼"H x 1 ⁷/₁₆"W; earrings: ¾"H x ⅜"W. Gift of the Stephen Phillips Memorial Charitable Trust for Historic Preservation, 2006.44.30.1-2ab.

3. Margaret Duncan Phillips (1847–1926). D. B. Vickery (photographer), Haverhill, Massachusetts, 1887. Gift of the Stephen Phillips Memorial Charitable Trust for Historic Preservation.

4. Ring. 1833. Gold, pearl, garnet. ⅜"W x ¹¹/₁₆"D. Gift of Ella Newton Rhoades, 1944.216.

5. Necklace. 1768–99. Wax, glass. 11"L. Bequest of William Perry Dudley, 1966.1390.

6. Theodora Kuhne and Albert Lawton. Unknown photographer, Somerville, Massachusetts, 1951. Courtesy of Monica Lawton.

7. Necklace. C. 1950. Glass, white metal. ⁹/₁₆" W x 11 ½"L. Gift of Mrs. Theodora Lawton, 1994.9.

8. Earrings. C. 1825. Glass, gold, foil, freshwater pearl, mother-of-pearl, horsehair. ⅝"W x ¾"L. Gift of the Misses Cummings, 1934.1844ab.

9. Hair comb. Possibly China, c. 1807. Mother-of-pearl. 4 ⅛"H x 3 ¼"W. Gift of Commodore Charles T. Pierce, 1930.1656.

CAMEOS

10. Set of jewelry in original box. Diego D'Estrada, Rome, 1855–65. Chalcedony, gold, leather, velvet, silk. Bracelet: 2 ⅛"W x ¾"D; brooch: 2 ¼"H x 2 ⅛"W; earrings: 1 ¹/₁₆"H x ¹³/₁₆"W. Gift of Miss Ellen F. Mason, 1930.177–179.

11. Brooch. Shreve, Crump & Low (retailer), Italy or America, c. 1870. Chalcedony, gold. 2"H x 1 ½"W. Gift of Hannah May Burrough Freeman, 1933.1462a.

12. Trade card for Shreve, Crump & Low. Gift of Mrs. H. E. Johnson, 1927.

13. Margaret Duncan Phillips (1847–1926). Morse's Palace of Art (photographer), San Francisco, California, 1876. Gift of the Stephen Phillips Memorial Charitable Trust for Historic Preservation.

14. Earrings and brooch. Salem, Massachusetts, 1870–76. Glass, gold, pearl. Brooch: 1 ⁹/₁₆"H x ⁵/₁₆"W; earrings: ¹³/₁₆"H x ⅜"W x 2 ½"L. Gift of the Stephen Phillips Memorial Charitable Trust for Historic Preservation, 2006.44.53a–c.

15. Brooch. Constantin Roësler Franz (retailer), Rome, Italy, 1840–60. Shell, gold. 1 ⅝"H x 2 ⁵/₁₆"W. Gift of Ralph May, 1971.2202a.

SPARKLE AND GLEAM

16. Brooch. United States, 1890–1920. 14K white gold, diamond. 2 ¹/₁₆"H x 1"W. Bequest of Eleanor Fayerweather, 1993.883.

17. Brooch. Possibly England, c. 1890. Diamond, platinum, gold. 2"H x 1 ½"W. Gift of the Stephen Phillips Memorial Charitable Trust for Historic Preservation, 2006.44.31.1.

18. Anna Wheatland Phillips (1870–1938). Unknown photographer, Lake Sunapee, New Hampshire, August 1900. Gift of the Stephen Phillips Memorial Charitable Trust for Historic Preservation.

19. Ring. Possibly Bigelow, Kennard & Co. (retailer), Europe or America, c. 1900. 14K gold, diamond, ruby. ¾" diam. Gift of the Stephen Phillips Memorial Charitable Trust for Historic Preservation, 2006.44.1.

20. Brooch. Probably Europe, 1860–1900. Garnet, gold. 2 ¾"L x 1 ¾"W. Bequest of Vipont de R. D. Merwin, 1966.2264.2.

21. Necklace. Individual pendants: 1860–1900; chain: 1860–80; necklace composed after 1900. Gold, peridot. 16"L; center pendant 2"L x 1 ½"W. Bequest of Vipont de R. D. Merwin, 1966.2330.

MEMORIAL

22. Set of jewelry. Stephen Twycross (c. 1745–c. 1822), London, England, c. 1796. Pearl, diamond, ivory, watercolor, gold. Earrings: ¾" H x ½" W; brooch: 1" H x ⅝" W; bracelet clasps: ¾"H x ½"W. Gift of Mrs. Francis Gray, 1953.42a–e.

23. Brooch. 1793. Enamel, gold, human hair, ivory. 1 ⁷/₁₆"H x 1"W. Gift of Miss Annie H. Thwing, 1918.1254.

24. Frances Bowdoin Bradlee (1849–1930). Unknown photographer, c. 1875. Bequest of Dorothy S. F. M. Codman, 1969.

25. Necklace. Possibly France, 1865–75. Glass, white metal, enamel. 18"L. Bequest of Dorothy S. F. M. Codman, 1969.3010.1.

26. Medal. Jacob E. Perkins (1766–1849), Newburyport, Massachusetts, 1800. Silver. 1 ⅛" diam. Gift of the Stephen Phillips Memorial Charitable Trust for Historic Preservation, 2006.44.95.

27. Ring. Probably Boston, 1766. Gold, enamel, paper, crystal. ¼"W x ¾"D. Gift of Mrs. John Binney and Miss Margaret Bush, 1935.646.

28. Ring. C. 1768. Gold, diamond, silver. ½"W x ¾"D. Bequest of Dorothy S. F. M. Codman, 1969.3072.

29. Brooch. England or America, c. 1848. Gold, enamel, glass, human hair. 1 ⅞"H x 1 ⅜"W. On loan from Mrs. John H. Morison, 78.1918.

30. Necklace and earrings. Probably United States, 1880–87. Jet, pearl, gold. Necklace: 11"L; earrings: 1 ½" L x ⅝"W. Gift of Mr. Harold W. Parsons, 1930.224–225.

LOVE TOKENS

31. Rings. Tiffany & Co. (retailer), Boston, Massachusetts, 1996. Gold. ⅞" diam. Gift of Stephen H. Borkowski in honor of the Michaud-Borkowski families, 2015.100.1.

32. Bracelets in original case. Tiffany & Co. (retailer), New York, c. 1899. Gold, leather, silk. ¾"W x 2 ⅜"D. Gift of the Stephen Phillips Memorial Charitable Trust for Historic Preservation, 2006.44.14.1ab.

33. Ring. Probably America, c. 1750. Silver, gold, glass. ¼"W x ¹³⁄₁₆"D. Gift of Miss Louise M. Dewey, 1927.914.

34. Ring. Probably United States, 1822. Gold, garnet. ¼"W x ³⁄₁₆"D. Gift of the Misses Cummings, 1934.1914.1.

35. Ring. Probably United States, 1780–1820. Gold. ¼"W x ¹³⁄₁₆"D. Gift of Mrs. John H. Edwards, 1921.341.

36. Mary Edwards Honey (1848–1900). Attributed to Jane Stuart (1812–1888), Newport, Rhode Island, c. 1868. Oil on canvas. 37"H x 29 ½"W. Estate of Vera G. Honey, 1997.92.

37. Brooch. Probably France, 1840–60. Tortoiseshell, gold. ½"H x 2 ³⁄₁₆"W. Gift of Miss Frances G. Curtis, 1922.220.

38. Watch chain. Providence, Rhode Island, 1830–40. Glass beads, flax. ¼"W x 27 ¼"L. Gift of Miss Lydia G. Chace, 1931.1804.

39. Bracelet. Possibly Providence, Rhode Island, c. 1885. Silver, "Liberty Seated" dimes. Pendants: ⅜" diam.; bracelet: 2 ⅜" diam. Gift of Miss Lydia G. Chace, 1929.1792.

À LA MODE

40. Earrings. Probably England, 1760–1800. Glass, pinchbeck. 1 ½"H x 1 ⅜"W. Gift of Miss Frances L. Chace, 1936.147ab.

41. Brooch. Probably England, 1770–1800. Gold, silver, glass, foil. 1"H x ¹⁵⁄₁₆"W. On loan from Miss Ellen A. Robbins Stone, 94.1918.

42. Cufflink. 1760–1800. Glass, gold, silver, foil. ⅜"H x ⅜"W. Gift of Miss Alice M. Burr, 1927.830.

43. Chatelaine. London, England, c. 1797. Pinchbeck, marcasite, ivory, watercolor. 1 ¼"W x 7 ¾"L. Gift of Miss Margaret F. Martin, 1948.128.

44. Shoe buckles. Possibly Birmingham, England, c. 1795. Silver, gold, glass. 2 ¾"H x 2 ¹⁵⁄₁₆"W x 1 ¾"D. Gift of Mrs. Francis Gray, 1953.41a–c.

45. Necklace. Probably Europe, 1830–50. Iron, enamel. ⅜"W x 21 ¾"L. Bequest of Dorothy S. F. M. Codman, 1969.3049.

46. Orange blossom headdress, earrings, and corsage. Probably United States, c. 1871. Silk, wax, metal. Headdress: 8 ½"L; earrings: ¾"L x ⅜"H. Gift of Hannah May Burrough Freeman, 1925.232.1–3.

47. Aigrette. Shreve, Crump & Low (retailer), Boston, Massachusetts, 1875–1900. Feather, paste, gold-plated metal. 6"H x 2"W x ½"D. Gift of the Stephen Phillips Memorial Charitable Trust for Historic Preservation, 2006.44.354.

48. Necklace. Possibly Finland, possibly by Aarikka (manufacturer), 1950–60. Wood, metal, monofilament. 17 ½"L; pendants: 3"L. Bequest of Ise Gropius, 1984.1426.

49. Ise Gropius (1897–1983). Unknown photographer, Lincoln, Massachusetts, c. 1960. Gift of Ati Gropius Johansen.

50. Necklace. John Johansen (1916–2012). New York or Wellfleet, Massachusetts, c. 1980. Steel. 18"L. Gift of Erika Pfammatter, 2014.157.12.

51. Necklace. Possibly Coro Inc. or Joseph H. Meyers & Brothers, probably Providence, Rhode Island, or New York, c. 1960. Plastic. ⅜"W x 5 ¾"L. Family of Nina Fletcher Little, 1993.61.

PORTRAITS

52. Sally Foster Otis (1770–1836). Edward Greene Malbone (1777–1807), Boston, Massachusetts, 1804. Ivory, watercolor, gilt metal, velvet. 6"H x 5 ¼"W x ¾"D. Gift of Miss Sophia H. Ritchie, 1947.783. Necklace and pendant. England, c. 1804. Carnelian, topaz, pearl, gold. Necklace: 9"L; pendant: 1 ¾"H x 1"W. Gift of Mr. and Mrs. William Platt Hacker, 1967.58.

53. Cameo. John A. Greenough (1801–1852), Massachusetts, 1849. Gold, shell. 3 ½"H x 2 ⅜"W. Gift of Mrs. J. Le Roy White, 1920.730.

54. Coat button and portrait of Elisha Doane (1762–1832). Probably America, 1780–83. Ivory, watercolor, gold, mother-of-pearl, silver. 1 ⅞"H x 1 ¼"W x ³⁄₁₆"D. Gift of Harriet M. Doane, 1937.1011ab.

55. Locket and portrait of Joseph Peabody (1824–?). Italy, 1870–90. Gold, ivory, micromosaic, watercolor. 2"H x 1 ³⁄₁₆"W x ⅝"D. Gift of the Stephen Phillips Memorial Charitable Trust for Historic Preservation, 2006.44.85.

56. Brooch. Lawrence Rhoades (1842–1910), Providence, Rhode Island, 1864–80. Tortoiseshell, albumen photograph, glass, ivory, silver. 1 ⁷⁄₁₆" diam. Gift of Ella Newton Rhoades, 1943.343.

57. Bracelet with portraits of Louis Agassiz (1807–1873), Alexander Dallas Bache (1806–1867), Benjamin Peirce (1809–1880), John Quincy Adams (1767–1848), Carl Friedrich Gauss (1777–1855), and John Adams (1735–1826). Probably Boston, 1845–61. Glass, gold, human hair, daguerreotypes. 1 ¼"W x 7 ½"L. Gift of Mrs. Albert Thorndike, 1919.243.

CHILDREN

58. Brooch with portrait of Elizabeth W. Gilbert (1838–?). Possibly by George Nichols Munger (1803–1882) or Caroline Munger, Mrs. H. B. Washburn (1808–1892), Boston, Massachusetts, 1839. Gold, ivory, watercolor, glass. 1 ¾"H x 1 ⁵⁄₁₆"W. Gift of Miss Grace Gilbert, 1932.224.

59. Rattle. Possibly England, 1780–1820. Silver, imitation coral (modern restoration). 4 ½"L x 2"W x 1"D. Gift of Miss Grace Gilbert, 1932.225.

60. Necklace. Probably Italy, c. 1840. Coral, gold. 17 $^{11}/_{16}$"L. Gift of Caroline A. Leighton, 1920.729.

61. Susan Ella Austin (1846–1921). Unknown photographer, c. 1855. Bequest of Edgar J. Rollins.

62. Earrings and bracelet. Probably England, 1840–60. Horsehair, metal. Bracelet: 2"W x 6 $^{1}/_{2}$"L; earrings: $^{15}/_{16}$"W x 2 $^{7}/_{8}$"L. On loan from Mrs. Albert G. Mason, 66.1933a–c.

63. Possibly Jane Appleton Phillips (1852–1935) or Jessie M. Kimball (1854–1945). C. D. Fredericks & Co. (photographer), New York, December 1866. Gift of the Stephen Phillips Memorial Charitable Trust for Historic Preservation.

64. Ring. Ostby & Barton (manufacturer), Providence, Rhode Island, c. 1942. Gold. $^{9}/_{16}$"H x $^{1}/_{2}$"W. Gift of Ralph C. Bloom, 2012.195.1.

SOUVENIRS

65. Brooch. Ireland, 1850–80. Bog oak. 1 $^{7}/_{8}$"H x 2 $^{5}/_{16}$"W. Gift of Miss Mary E. Beeler, 1933.1618.

66. Bracelet. Germany, 1840–60. Ivory. 2 $^{1}/_{8}$"H x 2 $^{1}/_{2}$"W. Estate of Mrs. Jane N. Grew, 1920.617.

67. Brooch. Probably Scotland, 1860–90. Agate, silver. $^{3}/_{4}$"H x 2 $^{1}/_{2}$"W. Gift of Miss Ruth L. S. Child, 1935.1449.

68. Necklace. Possibly from the Vatican, Rome, c. 1857. Gold, glass, thread. 16"L. Gift of Miss Jane S. Tucker, 1998.5137.1-3.

69. Set of vest buttons. Rome, Italy, 1855–65. Glass, gold. $^{9}/_{16}$" diam. Gift of Miss Ellen F. Mason, 1930.160.

70. Brooch. Kitching & Abud (retailer), London, England, c. 1850. Glass, gold. 1 $^{9}/_{16}$"H x 1 $^{7}/_{8}$"W. Gift of Miss Elizabeth G. Norton, 1933.279.

71. Set of jewelry. Mumbai, India, 1875. Tiger claws, gold. Necklace: 1 $^{3}/_{8}$"W x 19 $^{1}/_{4}$"L x $^{3}/_{8}$"D; bracelet: 1 $^{1}/_{2}$"W x 8 $^{1}/_{2}$"L x $^{3}/_{8}$"D; brooch: 1 $^{1}/_{2}$"H x 3"W; earrings: $^{7}/_{8}$"W x 2 $^{1}/_{2}$"L. Gift of Miss Louise M. Dewey, 1928.147–150.

72. Charm bracelet. Europe and America, c. 1935. Gold, silver, enamel. 5 $^{1}/_{4}$"L. Bequest of Vipont de R. D. Merwin, 1966.2323.

73. Charm bracelet. Europe and America, c. 1935. Gold, silver, enamel. 4 $^{5}/_{8}$"L. Bequest of Vipont de R. D. Merwin, 1966.2324.

74. Necklace. Japan, c. 1867. Straw, ivory, silver, garnet. 6"L. Gift of Miss Hannah May Burrough, 1925.244.

MADE IN NEW ENGLAND

75. "Skilled Workers Manufacturing Jewelry, Providence, R.I." Keystone View Company (photographer), c. 1910.

76. Bracelet. Louis Stern & Company (manufacturer), Providence, Rhode Island, 1920–40. Gold-plated metal. $^{3}/_{4}$"W, 2 $^{1}/_{4}$" diam. Gift of Julianne Mehegan, 2014.43.1.

77. Brooch. Frank Gardner Hale (1876–1945), Boston, Massachusetts, 1910–20. Gold, tourmaline. 1 $^{1}/_{4}$"H x 1 $^{1}/_{4}$"W. Museum purchase, 2014.70.1.

78. Brooch. Edward Everett Oakes (1891–1960), Wakefield, Massachusetts, 1930–50. Platinum, gold, diamond, opal, pearl, tourmaline. 1 $^{5}/_{8}$" diam. Gift of Barbara Wriston, 2004.14.7.

79. Rings. Edward Everett Oakes (1891–1960), Wakefield, Massachusetts, 1947. Platinum, gold, diamond, sapphire. $^{3}/_{4}$" diam. each. Gift of Barbara Wriston, 2004.14.10–11.

80. Ring. Parenti Jewelers (Zoe Parenti-Borghi [1902–1983] and Delfina Parenti [1900–1984]), Boston, Massachusetts, 1950–60. Silver, quartz or aquamarine. $^{7}/_{8}$"W, $^{11}/_{16}$" diam. Gift of Barbara Wriston, 2004.14.4.

81. Brooch. Coro Inc. (manufacturer), Providence, Rhode Island, 1940–50. Silver. 1 $^{1}/_{2}$"H x 1 $^{5}/_{8}$"W. Gift of Julianne Mehegan, 2014.144.1.

82. Brooch. Danecraft Inc. (manufacturer), Providence, Rhode Island, c. 1960. Sterling silver. 2"L x 1 $^{1}/_{4}$"W. Museum purchase, 2014.71.2.

83. Bracelet. Trifari, Krussman, and Fishel Inc. (manufacturer), New York and Providence, Rhode Island, 1937–42. Glass, rhodium-plated white metal. $^{7}/_{16}$"W x 6 $^{3}/_{4}$"L. Gift of Nancy Curtis, 2013.139.1.

84. Brooch. Ed Wiener (1918–1991), Provincetown, Massachusetts, or New York, 1940–60. Silver. 1 $^{1}/_{2}$"H x 1 $^{1}/_{2}$"W. Gift of Donald M. Faber in memory of Lester and Adele Heller, 2016.5.2.

85. Brooch. Trifari, Krussman, and Fishel Inc. (manufacturer), New York and Providence, Rhode Island, c. 1955. Enamel, gold alloy, white metal. 1 $^{3}/_{8}$"H x 1 $^{3}/_{8}$"W. Gift of Julianne Mehegan, 2014.43.2.1.

86. Necklace. Carl Tasha (1943–2006), Provincetown, Massachusetts, 1960–70. Brass, leather. 2"H x 2 $^{1}/_{8}$"W x 12"L. Gift of Claire Sprague, 2015.99.1.1.

87. *Creation* cuff. Jason Brown (b. 1973), Bangor, Maine, 2015. Copper, brown ash. 2"H x 2 $^{3}/_{4}$"W x 1 $^{7}/_{16}$"D. Museum purchase, 2015.97.1.

88. *Alliance* collar. Elizabeth James-Perry (b. 1973), Dartmouth, Massachusetts, 2015. Quahog shell, sinew, brain-tanned deerskin. 41"L x $^{5}/_{8}$"W. Museum purchase, 2015.98.1.

CONCLUSION

Display stand and earrings. Various artists and manufacturers, 1950–70. 8 $^{1}/_{4}$"H x 4"W. Bequest of Ise Gropius, 1984.280.

INSIDE BACK COVER

Pocket watch, chain, and fob. Bigelow, Kennard & Co. (manufacturer), Boston, Massachusetts, c. 1890. Gold, glass. 1 $^{15}/_{16}$"H x 1 $^{3}/_{8}$"W x 7 $^{1}/_{4}$"L. Bequest of Susan B. Norton, 1990.4.

Brunialti, Carla Ginelli and Roberto Brunialti. *American Costume Jewelry: Art and Industry, 1935–1950*. 2 vols. Atglen, Pennsylvania: Schiffer Publishing, 2008.

Cera, Deanna Farneti, ed. *Jewels of Fantasy: Costume Jewelry of the 20th Century*. New York: Harry N. Abrams Inc., 1992.

Dietz, Ulysses G. *The Glitter and the Gold: Fashioning America's Jewelry*. Newark, New Jersey: The Newark Museum, 1997.

Fales, Martha Gandy. *Jewelry in America, 1600–1900*. Suffolk, U.K.: The Antique Collectors' Club, 1995.

Gere, Charlotte and Judy Rudoe. *Jewellery in the Age of Queen Victoria: A Mirror to the World*. London: The British Museum Press, 2010.

Holm, Christiane. "Sentimental Cuts: Eighteenth-Century Mourning Jewelry with Hair," *Eighteenth-Century Studies* 38:1 (Fall 2004), 139–43.

Markowitz, Yvonne. *Artful Adornments: Jewelry from the Museum of Fine Arts, Boston*. Boston: MFA Publications, 2011.

——. *Imperishable Beauty: Art Nouveau Jewelry*. Boston: MFA Publications, 2008.

Pointon, Marcia. *Brilliant Effects: A Cultural History of Gem Stones and Jewellery*. London: Paul Mellon Centre, 2010.

Rainwater, Dorothy T. *American Jewelry Manufacturers*. Atglen, Pennsylvania: Schiffer Publishing, 1988.

Schon, Marbeth. *Form & Function: American Modernist Jewelry, 1940–1970*. Atglen, Pennsylvania: Schiffer Publishing, 2008.

Sheumaker, Helen. *Love Entwined: The Curious History of Hairwork in America*. Philadelphia: University of Pennsylvania Press, 2007.

Stabile, Susan M. *Memory's Daughters: The Material Culture of Remembrance in Eighteenth-Century America*. Ithaca, New York: Cornell University Press, 2004.

Stewart, Susan. *On Longing: Narratives of the Miniature, the Gigantic, the Souvenir, the Collection*. Durham, North Carolina: Duke University Press, 1992.

GLOSSARY

Agate A type of chalcedony. When cut at an angle many agates show banding of light and dark stripes. See **chalcedony**.

Cameo A profile portrait or scene carved in relief, often on a background of a different color. Cameos may be made from shell, stone, or glass.

Carat A unit of weight measurement for gemstones, where one carat equals 200 milligrams and 142 carats equal one ounce. See **karat**.

Carnelian See **chalcedony**.

Chalcedony A type of cryptocrystalline silica available in a wide range of colors, often banded so that a jeweler could carve through one color to expose another. Carnelian, bloodstone, and onyx are all forms of chalcedony.

Coral A hard, outer skeleton composed of calcium carbonate exuded by a group of marine invertebrates.

Daguerreotype The first commercially successful photographic process introduced in 1839 and named after the inventor, Louis-Jacques-Mandé Daguerre.

Enamel The application of ground glass (sometimes called fondant) to a metallic surface, which is then heated to melt the glass, creating a transparent or translucent effect.

French jet A general term for imitation jet jewelry made from black or dark red glass and set on a black-enameled metal backing. See **jet**.

Garnet A silicate mineral used in jewelry for millennia. Garnets range in color from dark red to orange, yellow, and bright green based on their chemical composition.

Jet A semiprecious black material made from ancient trees fossilized under pressure; a precursor to coal. One of the largest sources for jet is the town of Whitby, in Yorkshire, England. See **French jet**.

Karat A designation of gold purity, measured as twenty-four times the pure mass divided by the total mass. For example, 24-karat gold is 99.9 percent gold by mass, while 18-karat gold is only 75 percent gold. See **carat**.

Marcasite Another term for iron pyrite, a crystalline form of iron sulfide known commonly as "fool's gold." When faceted and polished it looks similar to diamonds.

Micromosaic The formation of pictorial images using minute slivers of colored glass or gemstones set in a matrix.

Mother-of-pearl The inner, iridescent layer of some molluscs, also called nacre.

Parure A term for a set or group of jewelry, from the French *pareure*, to prepare or adorn. A full parure is a necklace, brooch, bracelet, and earrings but might also have included a tiara, multiple bracelets, and other types of jewelry.

Paste A term for faceted lead glass used to approximate precious gems. Because glass does not have the refractive index of gems, paste was often set with a metal foil backing to increase its brilliance.

Peridot The gem variety of the mineral olivine; also known as chrysolite. It varies from olive to bright green and can be found in basaltic lava flows and comets.

Pinchbeck An alloy of copper and zinc named for its inventor, London watchmaker Christopher Pinchbeck, who introduced his gold substitute in the early eighteenth century.

Piqué A term for tortoiseshell jewelry inlaid with gold, typically made in France in the middle to late nineteenth century.

Tourmaline A crystalline semiprecious stone with a variety of colors from green to yellow to pink, depending on its mineral components.

Wampum Beads formed from the white and purple shells of the quahog clam, native to the southeastern New England coast. The name is derived from the Wampanoag word for white shell beads: *wampumpeag*.

Laura E. Johnson is associate curator at Historic New England, where she specializes in jewelry, textiles, and Native American material culture. She received a PhD in the History of American Civilization from the University of Delaware and an MA in Early American Culture from the Winterthur Program. Dr. Johnson is the curator of the traveling exhibition *Mementos: Jewelry of Life and Love from Historic New England*.

Published by Historic New England
141 Cambridge Street
Boston, Massachusetts 02114
www.HistoricNewEngland.org

Distributed by University Press of New England
1 Court Street, Suite 250
Lebanon, New Hampshire 03766
www.upne.com

Cover: See page 32, object 39. Back cover: See page 53, object 77.

First edition 2016

Book and cover design by Wilcox Design, Cambridge, Massachusetts
Editorial production managed by Kristin Bierfelt and Lorna Condon
All photography by Historic New England staff, Colleen Mann, Adam Osgood, and Timothy Tiebout, except front cover, table of contents, foreword, and objects 1, 2, 4, 7, 9, 11, 15–17, 20–22, 25, 28–29, 33, 35, 39, 41, 43–45, 48, 51–52, 54–56, 58–60, 68, 71, 74, 79, 89, and inside back cover by Andrew Davis/Portside Creative
ISBN 978-0-9890598-3-1